Borderlines:
Drawing Border Lives

Fronteras:
Dibujando las vidas fronterizas

*This book is dedicated
to a future where everyone knows
that "the World is my Family."*

Borderlines:
Drawing Border Lives

Fronteras:
Dibujando las vidas fronterizas

Poetry by Steven P. Schneider
Drawings by Reefka Schneider

Introduction by Norma E. Cantú

Spanish translation by José Antonio Rodríguez

WingsPress

San Antonio, Texas

Borderlines: Drawing Border Lives / Fronteras: Dibujando las vidas fronterizas
© 2010, 2013 by Steven P. Schneider and Reefka Schneider

Cover image: Bryce Milligan, adapted relief map.

2013 Paperback Edition, ISBN: 978-1-60940-273-0
ePub: ISBN: 978-1-60940-015-6
Kindle ISBN: 978-1-60940-016-3
Library PDF ISBN: 978-1-60940-017-0

Wings Press
627 E. Guenther
San Antonio, Texas 78210
Phone/fax: (210) 271-7805

On-line catalogue and ordering:
www.wingspress.com
All Wings Press titles are distributed to the trade by
Independent Publishers Group
www.ipgbook.com

Printed in China.
All materials and inks used in the production
of this book meet United States standards for health and safety.

Library of Congress Cataloging-in-Publication Data (hardback edition):

Schneider, Steven P.
 Borderlines : drawing border lives = Fronteras : dibujando las vidas fronterizas : poetry / by
Steven P. Schneider ; drawings by Reefka Schneider ; introduction by Norma E. Cantú ; Spanish
translation by Jose Antonio Rodríguez.
 p. cm.
 Text in English and Spanish.
 ISBN 978-0-916727-65-9 (alk. paper) -- ISBN 978-1-60940-273-0 (paperback) -- ISBN
978-1-60940-015-6 (ePub ebook) -- ISBN 978-1-60940-016-3 (Kindle ebook) -- ISBN 978-1-
60940-017-0 (library PDF ebook)
 1. Mexican-American Border Region--Poetry. I. Cantú, Norma E. II. Title.

PS3619.C44715B67 2010
811'.6--dc22
 2009029906

Contents

Introduction

Norma E. Cantú, Ph.D.

The border es una herida abierta where the third world grates against the first and bleeds. – Gloria Evangelina Anzaldúa

For over thirty years I have been interested in the many ways that we can tend to the wound that Anzaldúa so aptly describes, how we can work at various levels to stave off the pain, to lessen the wounding and to foster the healing, to do "work that matters" as Anzaldúa also urges us to do. And aside from direct political activism, often it is in the cultural expressions on both sides of the border—in art exhibits, in poetry publications and readings, in the conjunto and accordion festivals, in the social and ritual dancing—that I have found at least one answer. Chicana and Chicano artists and poets along with Mexicana and Mexicano artists and poets have been engaged in this healing for a long time, but *Borderlines: Drawing Border Lives* comes to us from a couple of non-natives to the region or to the culture, activists whose drawings and words seek the same goals.

I first saw the drawings by Reefka Schneider on exhibit at the University of Texas-Pan American campus a few years ago. Subsequently I met her and Steven Schneider, the poet; they enthusiastically spoke of their labor of love, the exhibit and this book. I agreed to write a few words as a way of introducing the 25 portraits and the 25 poems for a number of reasons, but foremost is my desire to follow Anzaldúa's urging to do work that matters and to be inclusive in our work as we continue to bridge across differences. The Schneiders' two forms—image and poetry—happen to also be areas of interest to me in my own work as I reflect on the multifaceted cultural production along the border, including dance and music. The authors' aim is for their images and words to work in tandem to offer, as they say, "a reflection of life along the border." Yes. It *is* a reflection. But more than that, the book offers faces to the often unnamed and unknown characters who people that very real geophysical space that is our borderland, with all their idiosyncrasies, contradictions, and lives so inextricably linked por el solo hecho de estar en la frontera. The fact that the border serves as background anchors my comments in significant manner in that the faces and places we encounter in the poems and the drawings nos ubican, they place us, in the heart of tensions that we must still attend to if we are to truly and fully experience the border.

The faces come alive with a few strokes of charcoal, of conte, or pastel. Children and elderly. Men and women. Street musicians of various ages. A mariachi. A vegetable vendor. A rugged boot seller. The music—violin, guitar and the accordion's plaintive cry—seeps through. These vendors, musicians, dancers and beggars, too, invite us to know the people of the border. The sage and wise. The smiling or those with "lips sealed and mouth lined by disappoint-ment." The portraits tell stories in myriad and varied images. The poems tell stories, subtle and compact. "Rolando" tells his love story and "Happy Bead Seller" tells his in first person. Among others, "Progreso Street Vendor, Smiling" tells hers in second person. So many nameless children tell theirs in third: "Six Year Old Street Vendor" holds woven

handbags; "Young Street Musician" fingers the button accordion. And the silent adults of "Garlic Man," "Wise Woman with Rings," and "Mariachi Femenil," all telling stories. Of life. Of dreams. Of the border. The poet's voice weaving them all together.

But above and beyond the faces, the poems also situate the characters along the border—Ochoa's Flea Market ("Bienvenido El Ángel"), outside La Fogata on a Saturday ("Happy Bead Seller"), or on a rainy Thursday ("Young Street Musician") in that town ironically named Nuevo Progreso ("Sestina: The Color of Money"), that border town on the banks of the Río Bravo almost at the end where the Rio Grande empties into the Gulf of Mexico. The characters could be anywhere in Tecate or Nogales, in Reynosa, or Tijuana. But they are here where Tamaulipas and Texas meet, where the wound dates back to 1836 along that same border Anzaldúa knew so well. The Schneiders have crossed the bridge with charcoal, pastel, and conte, and with words. And we are the better for it. We peek into the lives of characters and learn to look beyond to the stories.

They conclude the book with two images *Es una mentira* and *Mass for the Disappeared* that serve as springboards for two longer poems of political commentary: "It's a Lie" and "Disappeared." An indictment of the border wall, the weak educational system, as well as of all political disappearances, the poems both localize ("It's a Lie" addresses issues specific to the Rio Grande Valley) and reach beyond the border femicides in Cd. Juarez as the litany includes those "Disappeared for wearing a Star of David" and remembers the "Disappeared in Chile," in Guatemala and in El Salvador. The social commentary is there earlier in other poems such as "A Heavy Burden" and "Beggar and Daughter" but in these it is the images that are stronger; in the last two the words hammer and hector the reader with the message. But it is in a good way; the subject matter demands no less.

Through images and words, this book invites us to reflect, to consider the stories, the lives and the realities of life on the U.S.-Mexico border. But it also impels us to dwell on our own work, asking us to tend to the wound that will not heal, to do work that matters.

Works Cited

Anzaldúa, Gloria, *Borderlands/La Frontera: The New Mestiza* (San Francisco: Aunt Lute Press, 1987).

Anzaldúa, Gloria E., "One Wound for Another: Let us be the healing of the wound" in *One Wound for Another / Una herida por otra: Testimonios de Latin@s in the U.S. Through Cyberspace (11 de septiembre de 2000-11 de marzo de 2002)*, edited by Claire Joysmith and Clara Lomas. (Mexico City: Colorado College, Universidad Autónoma de México, Whittier College.)

Borderlines:
Drawing Border Lives

Fronteras:
Dibujando las vidas fronterizas

Six-Year-Old Street Vendor

In her right ear she wears a pink stud.
Her lips are sealed and will not share the secrets
Of her family, the two room house
With dirt floors and no running water.
Her mother makes doilies and tablecloths
Sold at the basilica.
The handbags draped over each wrist
And around her neck
Are stitched by a cousin
Who lives in Matamoros.
They hang from her like ornaments.

She awakens each day, early
To walk the streets of Nuevo Progreso
Where she competes
With other child vendors—of watches, silver bracelets,
CDs of Tejano music.
She is intimate with the alleys of this border town—
Beggars with tin cans, children playing the accordion, stray cats.
She will never learn how to read and write.
She leaves only traces of her footsteps
On the muddy paths beside the Rio Grande.

Vendedora ambulante de seis años

En su oreja derecha trae un arete color de rosa.
Sus labios sellados no compartirán los secretos
De su familia, la casa de dos cuartos
Con piso de tierra y sin drenaje.
Su madre confecciona servilletas y manteles
Que se venden en la basílica.
Los bolsos colgados sobre cada muñeca
Y alrededor de su cuello
Son tejidos por una prima
Que vive en Matamoros.
Cuelgan de ella como adornos.

Despierta temprano cada diá
Para caminar por las calles de Nuevo Progreso
Donde compite
Con otros niños vendedores-de relojes, pulseras de plata,
Discos compactos de música tejana.
Es íntima de los callejones de este pueblo fronterizo-
Pordioseros con botes de lata, niños tocando el acordeón,
gatos extraviados.
Nunca aprenderá a leer ni escribir.
Deja sólo rastros de sus pasos
En los caminos lodosos al lado del Río Bravo.

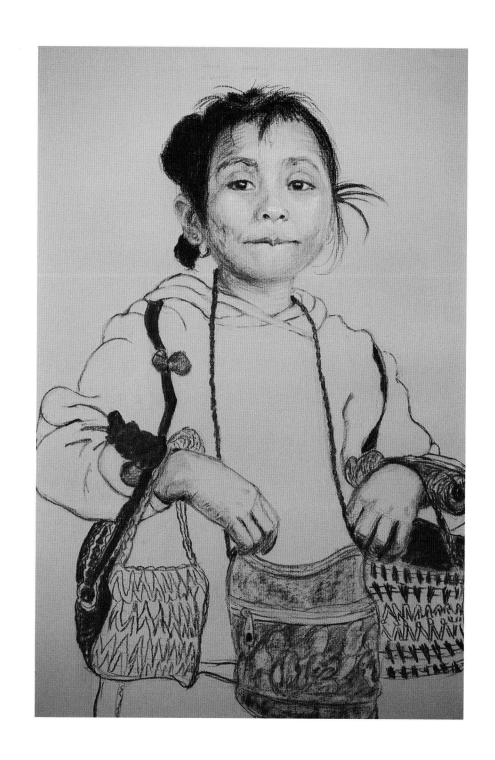

"Six-Year-Old Street Vendor"
Charcoal and conte
24 x 30 inches
(2004)

3

Hey, Garlic Man

You stand on the corner
With that garland of garlic
Hanging over your neck and shoulders.
Garlic the size of baseballs –
And sell them to Winter Texans
Wearing John Deere hats and blue jeans
Who come to Nuevo Progreso
To save a few bucks
On medications, haircuts, and shoe shines.
You stand out there each day in the sun
Wearing your orange cap,
Rugby shirt,
Looking out at the world
Like a man who has seen too much of it.
You wear that string of garlic
Around your neck
Like a snake charmer.
You honor the scent of the earth.
You take their cash
And send the visitors home
With those big white cloves of garlic
Grown in the fields of Tamaulipas.
Garlic,
Garlic,
Garlic:
To be sliced into frying pans,
Diced into salsa,
Cooked in tomato sauce,
To add savor and luck
To this unsavory, unlucky world.

Oye, hombre del ajo

Te paras en una esquina
Con esa guirnalda de ajo
Colgada de tu cuello y hombros.
Ajo del tamaño de pelotas de béisbol—
Y se los vendes a los ancianos del norte
Que visten cachuchas de John Deere y pantalones de mezclilla
Y que vienen a Nuevo Progreso
Para ahorrarse unos cuantos pesos
En medicinas, cortes de cabello, y lustradas de calzado.
Te paras cada día allá afuera en el sol
Usando tu gorra anaranjada,
Camiseta de rugby,
Contemplando al mundo
Como un hombre que ha visto demasiado de él.
Llevas esa ristra de ajo
Alrededor de tu cuello
Como un encantador de serpientes.
Honras el aroma de la tierra.
Tomas su dinero
Y despachas a los visitantes a casa
Con esos dientes de ajo grandes y blancos
Cultivados en los campos de Tamaulipas.
Ajo,
Ajo,
Ajo:
Para ser tajado en la sartén,
Picado en salsa,
Cocido en salsa de tomate,
Para agregarle sazón y suerte
A este mundo desabrido y desdichado.

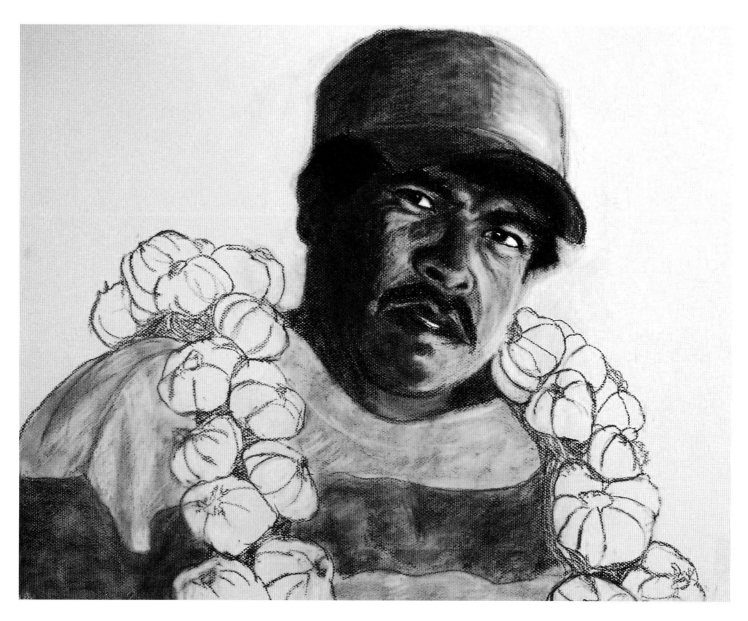

"Garlic Man"
Conte, 30 x 24 inches (2004)

5

Mariachi With a Red Violin

This is a drawing of
Concentration: the red violin
Tucked firmly beneath his chin,
The bow held lightly
In his right hand,
The fingers of the left
Positioned carefully on the strings.

This young man
Prepares to play
The song from some warm night
On a square in Mexico City,
Where his grandfather listened
To the speeches of politicians.

He looks out beyond his red violin
As if he sees
In the distance a young woman
In a violet rebozo,
Waiting for him on her balcony.

He begins to move the bow,
And she tosses him a white gardenia,
The evening air scented by its perfume
And the ballad of love he will play.

El mariachi con violín rojo

Este es un dibujo de
Concentración: el violín rojo
Firmemente encajado debajo de su barbilla,
El arco ligeramente empuñado
En su mano derecha,
Los dedos de la izquierda
Cuidadosamente colocados sobre las cuerdas.

Este joven
Se prepara para tocar
La canción de alguna noche cálida
En una plaza de la ciudad de México,
Donde su abuelo escuchó
Los discursos de los políticos.

Mira más allá de su violín rojo
Como si viera
En la distancia a una joven
En un rebozo color violeta
Esperándolo desde su balcón.

Empieza él a mover el arco
Y le lanza ella una gardenia blanca,
El aire de la noche perfumado por su aroma
Y por la balada de amor que él tocará.

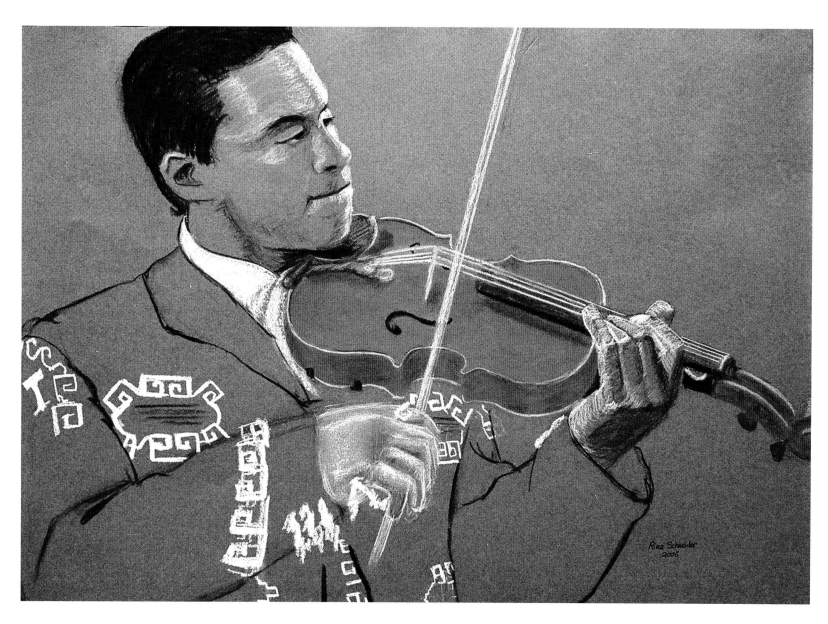

"Mariachi With a Red Violin"
Charcoal and conte, 30 x 24 inches (2004)

7

Beggar and Daughter

Cuando hay hambre, no hay mal pan.

This young girl chews on a plastic card—
The streets of Nuevo Progreso, fall
Ten years after NAFTA, hungry
Brown eyes wide open.
She leans her head back against her mother,
Jacket zipped up against the wind.
A few strands of hair hang down over her forehead.
Maquilas along the border have closed down.
The number of trucks crossing the bridge
With automobile parts, washing machines, denim shirts
and pants
Has slowed to a trickle.
She owns only this card in her mouth.

Her mother cannot afford to buy her a bracelet
Or a brightly colored frog or crab from Oaxaca.
She wears a striped sarape across the shoulders.
Her lips are sealed, mouth lined by disappointment,
Eyes glazed with fear.
Trapped in an economy
Of harsh winds and muddy streets,
She looks at you in sadness
Her dreams void
Of magic animals or hope.

Pordiosera e hija

Cuando hay hambre, no hay mal pan.

Esta niñita mastica una tarjeta de plástico –
Las calles de Nuevo Progreso, otoño
Diez años después del TLC, hambrientos
Ojos color café abiertos de par en par.
Recarga su cabeza sobre su madre,
La chaqueta cerrada contra el viento.
Unos cuantos cabellos caen sobre su frente.
Las maquilas de la frontera se han cerrado.
El número de camiones que cruzan el puente
Con auto partes, lavadoras, pantalones y camisas de mezclilla
Se ha disminuido a un goteo.
Es dueña sólo de esta tarjeta en su boca.

Su madre no tiene para comprarle una pulsera
Ni un sapo o cangrejo de color brillante de Oaxaca.
Lleva un sarape rallado de hombro a hombro.
Sus labios sellados, la boca marcada por la desilusión.
Los ojos vidriosos de miedo.
Atrapada en una economía
De vientos ásperos y calles lodosas,
Te mira con tristeza
Sus sueños vacíos
Sin animales mágicos ni esperanza.

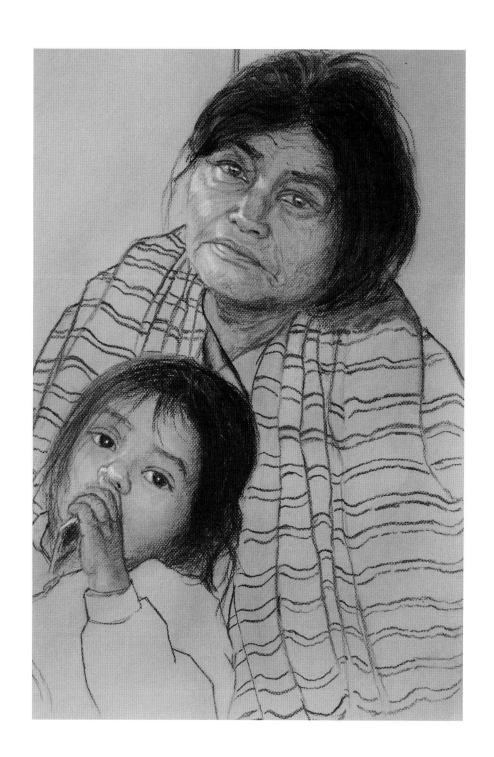

"Beggar and Daughter"
Charcoal and conte
24 x 30 inches
(2004)

9

Bienvenido el Ángel

El Ángel
Is eating a chili pepper
At the taquería which bears his name
On a Sunday afternoon in late October
At Ochoa's Flea Market.
El Ángel likes tacos too
And the young girls
Who wait on tables
And serve chicharrones, nopalitos, and tamales
To the customers.
The young girls who wear Día de los Muertos
Pumpkin orange t-shirts
With skeletons
That smile and say "dead to the bone."
One of them brings out a steaming
Bowl of menudo
To a white-haired, toothless old woman named Rosa
Who has lived all her life in Mission, Tejas
And comes to the mercado
With her nieces and their children
On Sundays
After attending her church
Named "the Messiah."
She finds comfort here
Among the workers eating their gorditas
And the conjunto music playing in the background,
And El Ángel on the billboard
Blessing the food on the table.

Bienvenido el ángel

El Ángel
Se come un chile
En la taquería que lleva su nombre
Un domingo de octubre por la tarde
En la pulga de Ochoa's.
Al Ángel le gustan los tacos también
Y las jóvenes
Que atienden las mesas
Y sirven chicharrones, nopalitos y tamales
A los clientes.
Las jóvenes visten camisetas anaranjadas como calabaza
De día de los muertos
Con esqueletos
Que sonríen y dicen "muerto hasta la médula."
Una de ellas le trae un vaporoso
Tazón de menudo
A una anciana canosa y desdentada que se llama Rosa
Y que ha vivido toda su vida en Mission, Tejas
Y viene al mercado
Con sus sobrinas y los hijos de ellas
Los domingos
Después de asistir a la iglesia
Llamada "The Messiah."
Aquí siente consuelo
Entre los trabajadores comiendo sus gorditas
Y la música de conjunto sonando en el fondo
Y El Ángel en la cartelera
Bendiciendo la comida sobre la mesa.

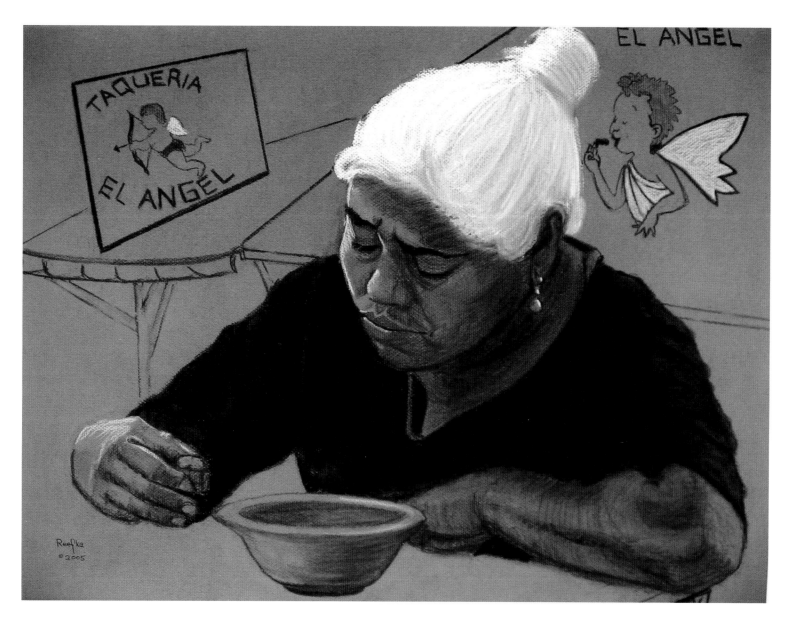

"El Ángel"
Charcoal and pastel, 30 x 24 inches (2005)

Three-Year- Old Street Musician

You hug the accordion
As if it were your baby brother
And look out at the world
With the sad eyes of a panda bear
Taken from its natural habitat.
You play a song for all the children to hear
Who stand in the rain with a candle in one hand
And a cup in the other hand.
You play for all the lost children
Who have disappeared in wars,
In the crevices of earth,
In floods of the seas.

You play a song
For all the children
Who go hungry,
For all the children
Who sleep at night on dirt floors,
For all the children
Who never saw another butterfly.

Músico callejero de tres años

Abrazas el acordeón
Como si fuese tu hermanito
Y alzas tu mirada al mundo
Con los ojos tristes de un oso panda
Cogido de su hábitat natural.
Tocas una canción para que la oigan todos los niños
Parados bajo la lluvia con una vela en una mano
Y una taza en la otra.
Tocas por todos los niños perdidos
Que han desaparecido en las guerras,
En las grietas de la tierra,
En las torrentes de los mares.

Tocas una canción
Por todos los niños
Que pasan hambre,
Por todos los niños
Que pasan la noche sobre piso de tierra,
Por todos los niños
Que jamás vieron otra mariposa.

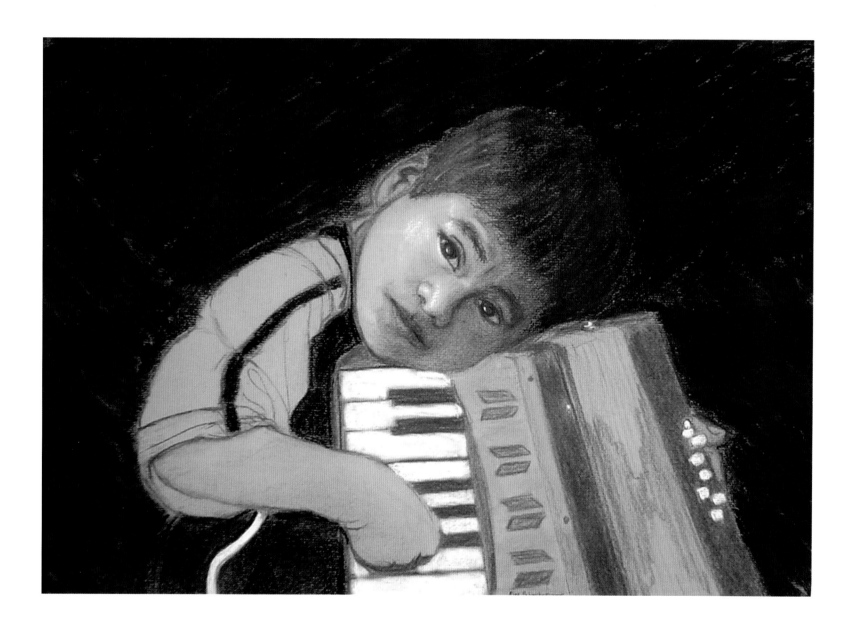

"Three-Year-Old Street Musician"
Charcoal and conte, 28 x 22 inches (2005)

13

Boot Seller

You sit back in your leather chair
With that white sombrero on your head
And smile out at the world
That passes by your stall at the Mission flea market
Where you sell Western boots
To construction workers from Oaxaca,
To migrant workers from Camargo,
To fruit sellers from Nuevo Guerrero.
Your smile is as wide as the Gulf of Mexico
And you listen all day to rancheras and conjunto music
On the radio.
You are happy to be sitting here.
You are happy to be selling these leather boots,
Polished and shiny in the heat of the day.
You cradle in your hands a cell phone
As if you hold the world in your fingertips.
You talk to those who enter your outdoor tienda
And listen to their stories of coyotes,
The women and children they have left behind.
You listen to their struggles to find work.
You are a man comfortable
Selling boots at the Mission flea market
Close to the fruit stands and the jewelry sellers
And the used clothes on the racks.
You are proud of the boots on your shelves
And the vast expanse of desert you have crossed.
You have a glint in your eyes of a man
Who has made it on this side of the Rio Grande
Content to sell these boots
On a sunny afternoon in a flea market in Mission, Tejas.

El vendedor de botas

Te recuestas sobre tu silla de cuero
Con ese sombrero blanco en tu cabeza
Y le sonríes al mundo
Que pasa por tu puesto en la pulga de Mission
Donde les vendes botas vaqueras
A los obreros de Oaxaca,
A los trabajadores migrantes de Camargo
A los vendedores de fruta de Nuevo Guerrero.
Tu sonrísa es ancha como el golfo de México
Y escuchas las rancheras y la música de conjunto todo el día
Por la radio.
Eres feliz sentado aquí.
Eres feliz vendiendo estas botas de cuero
Boleadas y lustrosas bajo el calor del día.
Sostienes en tu mano un teléfono celular
Como si este fuese el mundo.
Platicas con aquéllos que entran a tu tienda al aire libre
Y escuchas sus historias de coyotes,
De las mujeres y los niños que han dejado atrás.
Escuchas de sus luchas por encontrar trabajo.
Eres un hombre contento
De vender botas en la pulga de Mission
Al lado de los puestos de fruta y de los joyeros
Y de la ropa usada en el perchero.
Sientes orgullo al ver tus botas en las repisas
Y saber del desierto inmenso que has atravesado.
En tus ojos hay el brillo de un hombre
Que ha sobresalido en este lado del Río Bravo
Satisfecho de vender estas botas
Una tarde asoleada en una pulga de Mission, Tejas.

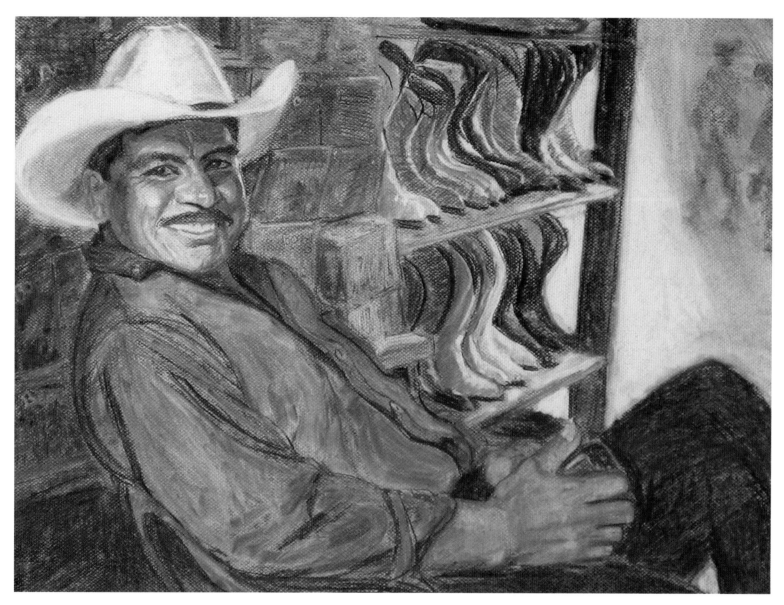

"Boot Seller"
Charcoal, 30 x 24 inches (2005)

Sestina: The Color of Money

These two children look out in quiet despair –
The young girl's hand on her brother's shoulder
Her left arm draped with plastic shopping bags.
He is carrying a box of candies
That he sells here in Nuevo Progreso
With his sister close by his side.

The two of them are standing side by side
In a world uncaring of their despair
On the main streets of Nuevo Progreso.
His head reaches up to her shoulder.
Tourists cross the river to buy candies,
Silver bracelets, tequila for their bags.

The vendors sell colorful knitted bags
When you cross the bridge to the other side
Of the Rio Grande, and sweet candies,
Where the street musicians play in their despair,
An accordion draped around a shoulder
In this border town, Nuevo Progreso.

These children who sell in Nuevo Progreso
Walk the streets with clear and colorful bags
Carrying them on the arm and shoulder
For the tourists who cross from the other side.
Their eyes express the meaning of despair
In the small world where they sell these candies.

In the small world where they sell these candies
They walk the streets of Nuevo Progreso

To help feed themselves and ward off despair.
The tourists who buy the different bags
And travel to here from the other side
Wear slick cameras draped around their shoulder.

Her hand touches lovingly his shoulder.
This young boy who holds a box of candies
Is glad his sister is close by his side.
These two youngsters who know Nuevo Progreso
And sell to the tourists cheap shopping bags
Look out at the world beyond their despair.

Prepare to buy their candies and the bags
They sell on the other side to shoulder
Despair and sorrow in Nuevo Progreso.

La sextina: el color del dinero

Estos dos niños alzan su mirada en una quieta desesperanza
La mano de la joven junto a su hermano, sobre su hombro
Su brazo izquierdo colgado de bolsas.
El carga una caja de dulces
Que vende aquí en Nuevo Progreso
Con su hermana a su lado.

Los dos están parados de lado a lado
En un mundo indiferente a su desesperanza
En las calles principales de Nuevo Progreso.
La cabeza del hermano alanza su hombro.
Los turistas cruzan el río para comprar dulces,
Pulseras de plata, tequila para sus bolsas.

Los vendedores venden coloridos tejidos hechos bolsas
Cuando cruzas el puente al otro lado
Del Río Bravo, y dulces dulces,
Donde los músicos de la calle tocan su desesperanza,
Un acordeón colgado sobre un hombro
En este pueblo fronterizo de Nuevo Progreso.

Estos niños de Nuevo Progreso
Van por las calles vendiendo el color de sus bolsas
Cargándolas sobre sus brazos y sus hombros
Para los turistas que cruzan del otro lado.
Sus ojos representan el significado de la desesperanza
En este pequeño mundo donde venden sus dulces.

En este pequeño mundo donde venden sus dulces
Caminan por las calles de Nuevo Progreso
Para poder comer y ahuyentar la desesperanza.
Los turistas que compran las diferentes bolsas
Y viajan aquí desde el otro lado
Llevan cámaras finas colgadas sobre sus hombros.

Su mano cariñosamente roza su hombro.
Este niño con su caja de dulces
Está contento de que su hermana esté a su lado.
Estos dos niños que conocen Nuevo Progreso
Y venden a los turistas sus baratas bolsas
Miran hacia el mundo más allá de su desesperanza.

Prepárate para comprar sus dulces y sus bolsas
Que venden en el otro lado para sostener sobre sus hombros
La desesperanza y el dolor en Nuevo Progreso.

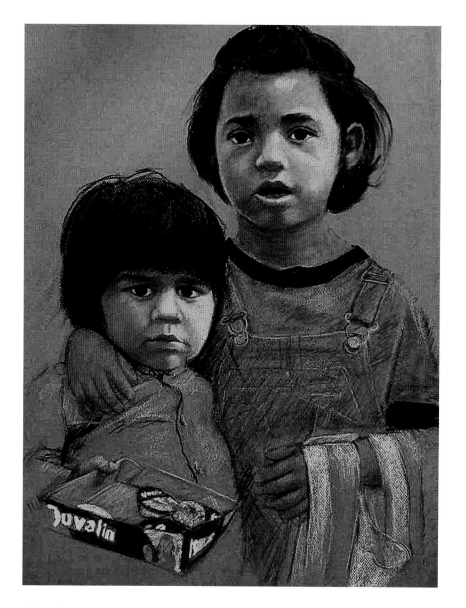

"The Color of Money"
Charcoal and pastel
24 x 30 inches
(2005)

17

Vaquero de Veracruz

It is a long way vaquero
From the cattle you worked on the ranch
Outside Veracruz.
I see you here
In your soft, white Stetson hat
Shiny leather Western boots
Your blue jeans and construction worker shirt,
A long way
From the chaparral
And the saddle horses,
A long way
From the campfires
Under the starry Mexican sky.

You have come to the Valley
To lasso a new life
On this side of the Rio Grande
And work construction for money
To send your family back home.
You come to the mercado
On Sundays to listen to rancheras played on CDs
And dream of riding in the saddle
Across the land
Slowly sold and corralled.

Vaquero de Veracruz

Estás bien lejos, vaquero
de las reses que cuidaste en el rancho
En las afueras de Veracruz.
Te veo aquí
Con tu sombrero Stetson liso y blanco
Botas vaqueras de cuero lustrosas
Tus pantalones de mezclilla y camisa de obrero,
Bien lejos
Del chaparral
Y los caballos montados,
Bien lejos
De las hogueras de campamentos
Bajo el cielo estrellado de México.

Has venido al valle
A lacear una vida nueva
En este lado del Río Bravo
A trabajar de obrero por dinero
Para mandarle a tu familia allá en casa.
Vienes al mercado
Los domingos para escuchar las rancheras
en los discos compactos
Y soñarte montado en la silla
Atravesando la tierra
Lentamente acorralada y vendida.

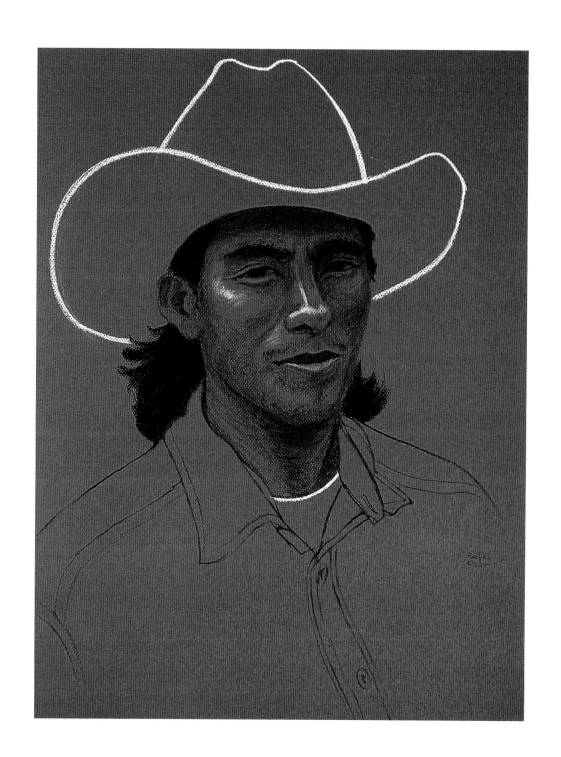

"Vaquero de Veracruz"
Charcoal and conte
24 x 30 inches
(2005)

Alegría

The happiness of la música!
The heart of happiness hanging from your necklace!
The smile of happiness on your face!
Alegría!
The happiness of purple lipstick!
The happiness of the guitar in your hands!
The happiness of love!
Alegría!
The happy times singing corridos!
The happiness of couples dancing!
The happiness of sangría!
Alegría!
The happiness of being happy!
The happy, happy happenings!
Happy to be playing all night long!
Alegría!

Alegría

¡La alegría de la música!
¡El corazón de la alegría colgado de tu collar!
¡La sonrisa alegre en tu rostro!
¡Alegría!
¡La alegría del lápiz labial color violeta!
¡La alegría de la guitarra en tus manos!
¡La alegría del amor!
¡Alegría!
¡Los momentos alegres cantando corridos!
¡La alegría de las parejas bailando!
¡La alegría de sangría!
¡Alegría!
¡La alegría de estar alegre!
¡Los alegres alegres acontecimientos!
¡Alegre de estar tocando toda la noche!
¡Alegría!

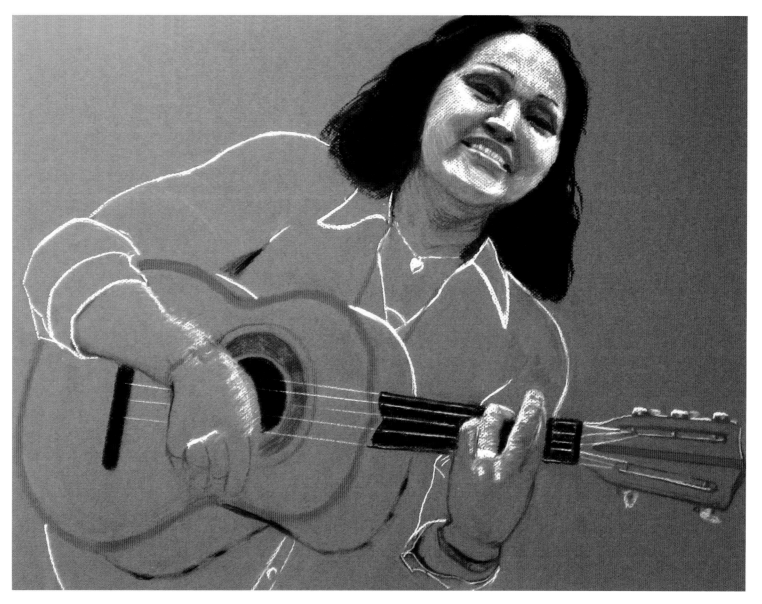

"Alegría"
Charcoal and pastel, 30 x 24 inches (2005)

Proud Vendedor

You stand in front of the fruits and vegetables
You sell at your open-air tienda
At Ochoa's Flea Market each weekend
In your Levis and leather belt from Guadalajara
Your sleeves rolled up, the collar
Of your red and white checkered shirt unbuttoned
A man happy to be here
Wearing a San Antonio Spurs championship hat
And selling red and green chili peppers
Carrots, cucumbers, cabbages,
To cabinet workers from Michoacán,
Locksmiths from Tampico.

Weekdays you drive a tractor
And work the sugarcane fields
On old Military Highway.

Weekends you sell fruits and vegetables
To support your family:
Your three children who work beside you,
Your wife and your nieces and nephews
Who bag the peppers and tomatoes
For all who come in their Texas Longhorn hats
And Tommy Hilfiger shirts
(Bought for less at the mercado on Conway)
And drink fruit cocktails from Castañeda's.
Afterwards they watch La Lucha Libre
Each Sunday afternoon in the tin shed nearby
Where El Rey del Camino
Takes on the Black Venom.

El vendedor orgulloso

Te paras frente a las frutas y verduras
Que vendes en tu tienda al aire libre
En la pulga Ochoa cada fin de semana
En tus pantalones Levis y cinto de cuero de Guadalajara
Las mangas arremangadas, el cuello
De tu camisa de cuadros rojos y blancos desabrochado
Un hombre feliz de estar aquí
con un sombrero del campeonato de los Spurs de San Antonio
Y vendiendo chile colorado, chile verde
Zanahorias, pepinos, repollos,
A ebanistas de Michoacán,
Cerrajeros de Tampico.

Durante la semana conduces un tractor
Y trabajas en los campos de caña dulce
Por la autopista Militar.

Los fines de semana vendes frutas y verduras
Para mantener a tu familia,
Tus tres hijos quienes trabajan a tu lado,
Tu esposa y tus sobrinos
Quienes embolsan los chiles y tomates
Para todos los que vienen con sus gorras
de los Longhorns de Tejas
Y sus camisas de Tommy Hilfiger
(mas baratas en el mercado de la Conway)
Y toman cócteles de fruta de Castañeda's.
Después ven la lucha libre
Cada domingo por la tarde en el cobertizo de hojalata cercano
Donde El Rey del Camino
Lucha contra el Black Venom.

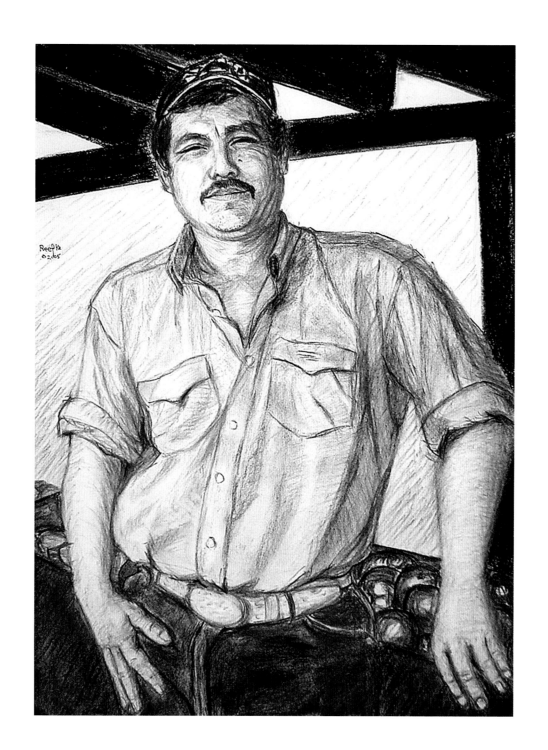

"Proud Vendedor;
Mission, Texas"
Charcoal
24 x 30 inches
(2005)

23

Little Dancer

After Edgar Degas

Oh young girl with crinkly bow in your hair
That looks like a magical gardenia,
How did you come to sit on the floor so poised?
Flopped down on the stage with your dancer's skirt
Spread out like a parachute on the ground,
Are you waiting for violins to sing?
One day you will dance a ribbon of steps
Across a pinkish stage flooded with lights
And bow to receive a bouquet of roses.
Sitting there in white gloves and satin shoes
You look up forlornly as if to ask
When will it be my turn to leap and whirl?

Pequeña bailarina

Al estilo Edgar Degas

O niña joven con moño ondulado en tu cabello
Que parece una gardenia mágica,
¿Cómo es que llegaste a sentarte en el suelo con tanta serenidad?
Echada sobre el escenario con tu falda de bailarina
Desenvuelta como un paracaídas en el suelo,
¿Estás esperando que canten los violines?
Un día bailarás, tus pasos como un listón
Sobre un escenario color de rosa lleno de luces
Y te inclinarás para recibir un ramo de rosas.
Sentada ahí con guantes blancos y zapatillas de satén
Alzas la mirada solitariamente como preguntando
¿Cuándo será mi turno para saltar y girar?

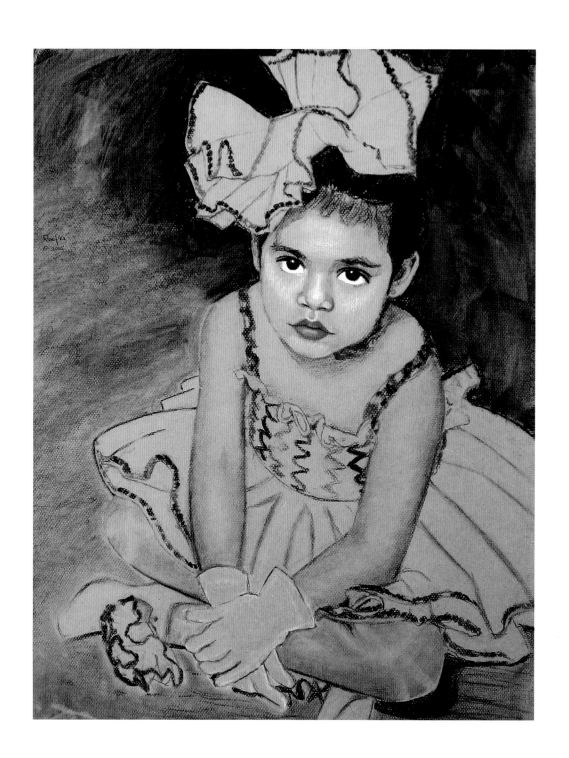

"Little Dancer"
Charcoal and pastel
24 x 30 inches
(2005)

25

Wise Woman With Rings

What do you know?

You know the rings,
The silver circles of light,
The roundness of the rim of the flower pot,
The roundness of pupils of the eyes,
The depths of their wells.
You know the roundness of pebbles on sand.

You know the children asleep on the floor.
You know hunger and pain.
You know the sun and the moon.
You know the desert and the sea.
You know when to fold your arms
Like the wings of an angel.

You sell these rings
As if they held all the mysteries of the universe,
All the stars in the vast heavens,
All the butterfly flowers on earth,
The silver circles of light
Spread before you on the table of life.

Sabia mujer con anillos

¿Tú qué sabes?

Los círculos plateados de luz,
La redondez del borde de la maceta,
La redondez de las pupilas de los ojos,
La profundidad de sus norias.
Sabes de la redondez de guijarros en la arena.

Sabes de los niños dormidos en el suelo.
Sabes de hambre y dolor.
Sabes del sol y la luna.
Sabes del desierto y del mar.
Sabes cuando cruzar los brazos
Como las alas de un ángel.

Vendes estos anillos
Como si poseyeran todos los misterios del universo,
Todas las estrellas del firmamento inmenso,
Todas las flores de mariposas de la tierra,
Los círculos plateados de luz
Puestos ante ti en la mesa de la vida.

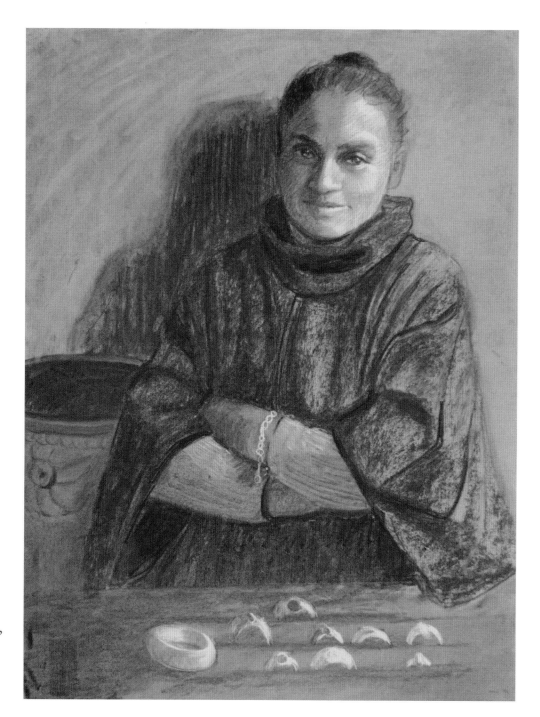

"Wise Woman With Rings"
Charcoal and conte
24 x 30 inches
(2008)

27

Triolet

She tucks the violin beneath her chin—
Her eyes are dark, she will not frown or grin.
This Mariachi Femenil will win.
She tucks the violin beneath her chin
Plays her ballad of betrayal and chagrin—
A woman in black, a man who will sin.
She tucks the violin beneath her chin—
Her eyes are dark, she will not frown or grin.

Triolet

Aprieta el violín debajo de su barbilla—
Sus ojos son oscuros, no hará ceño ni mueca.
Este Mariachi Femenil ganará.
Aprieta el violín debajo de su barbilla
Toca su canción de traición y aflicción—
Una mujer de negro, un hombre que pecará.
Aprieta el violín debajo de su barbilla—
Sus ojos son oscuros, no hará ceño ni mueca.

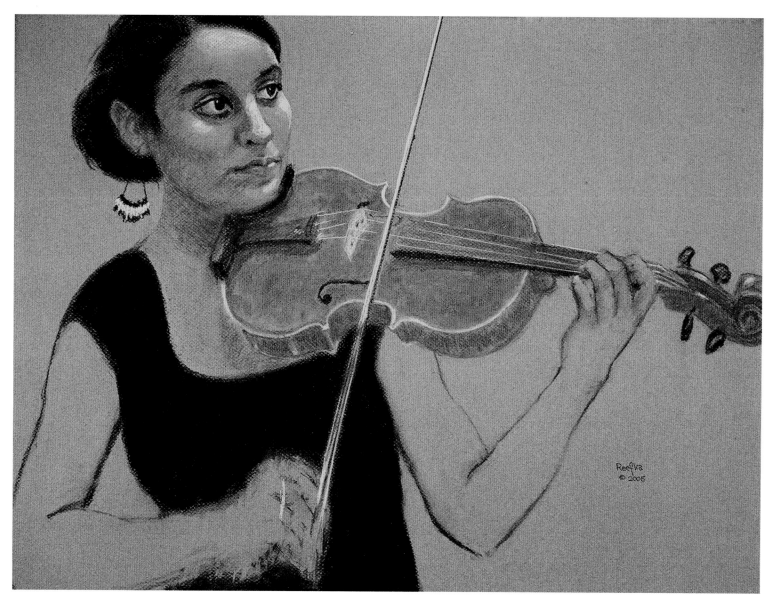

"Mariachi Femenil"
Charcoal and conte, 30 x 24 inches (2005)

29

Progreso Street Vendor, Smiling

You came to this border town
To look for work to feed your children.
You tied your hair back
To prevent the wind
From blowing strands in your face.
You look out at the world
With eyes that long for sleep
And the cool shade of mesquite trees.
You dream of a small village you left behind.
Your face is etched with lines
Of the dark history of your family.
You sell garlic and avocados to feed them.
You sell bracelets and pocket mirrors too.
You understand the vanity of tourists
With their headsets and designer jeans
And big red bolsas they carry proudly on their arms.
Everyday you see beggar women on the street
With their babies and tin cans.
Everyday you see small children play the accordion
For spare change.
You hear songs of the mariachis tumble
Out of the barrooms.
You wince in the heat of the sun.
You wince at the dryness of the Rio Grande.
You know what it is to nurse and cook for five children.
You care for an aging mother.
You taste the bitter sweetness of love lost and found.
You smile through your pain.

Vendedor ambulante de progreso que sonríe

Viniste a este pueblo fronterizo
En busca de trabajo para alimentar a tus hijos.
Te recogiste el cabello
Para que el viento
No te lo echara en la cara.
Contemplas al mundo
Con ojos que ansían el sueño
Y la sombra fresca del mesquite.
Sueñas con el pequeño pueblo que dejaste atrás.
Tu rostro está grabado con las líneas
De la obscura historia de tu familia.
Vendes ajo y aguacate para alimentarlos.
También vendes pulseras y espejos de mano.
Entiendes la vanidad de los turistas
Con sus juegos de audiófonos y pantalones de mezclilla de marca
Y grandes bolsas rojas que llevan orgullosamente en sus brazos.
Todos los días ves a mujeres pidiendo en la calle
Con sus bebés y sus botes de lata.
Todos los días ves a niñitos tocar el acordeón
Por monedas.
Oyes las canciones del mariachi salir tambaleando
De las cantinas.
Te encoges bajo el calor del sol.
Te encoges ante la aridez del Río Bravo.
Sabes lo que es criar y cocinar para cinco hijos.
Cuidas a una madre anciana.
Saboreas la dulzura amarga del encuentro y desencuentro del amor.
Sonríes entre el dolor.

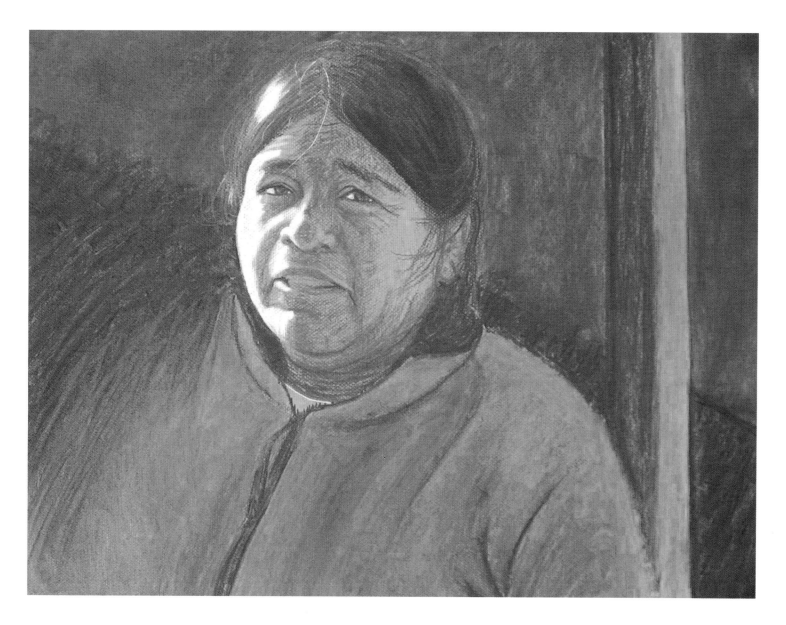

"Progreso Street Vendor, Smiling"
Charcoal and conte, 30 x 24 inches (2006)

31

Two-Year- Old Street Musician

This young street musician
With pink barrettes in her pigtails
Holds the accordion
Like an unearthed treasure
Between her hands
And squeezes from it a piece of conjunto music.

The silver-haired men and women
From Red Cloud and Holdrege
Who come to this border town
To buy papier-mâché flowers,
Silver bracelets, and glazed ceramic ware

Start tapping their feet
As if they were at a polka
On a Sunday afternoon picnic
In Nebraska.

The faster the rhythm,
The more coins they toss
Into her cup.

La músico ambulante de dos años

Esta niña, músico ambulante
Con piochas color de rosa en sus chonguitos
Toma el acordeón
Como un tesoro descubierto
Entre sus manos
Y le exprime una pieza de música de conjunto.

Los hombres y mujeres encanados
De Red Cloud y Holdrege
Que vienen a este pueblo fronterizo
A comprar flores de cartón piedra,
Pulseras de plata y cerámica vidriada

Empiezan a zapatear sus pies
Como si estuviesen en una polca
Un domingo por la tarde en el campo
De Nebraska.

Entre más acelera el ritmo
Más monedas le arrojan
En su taza.

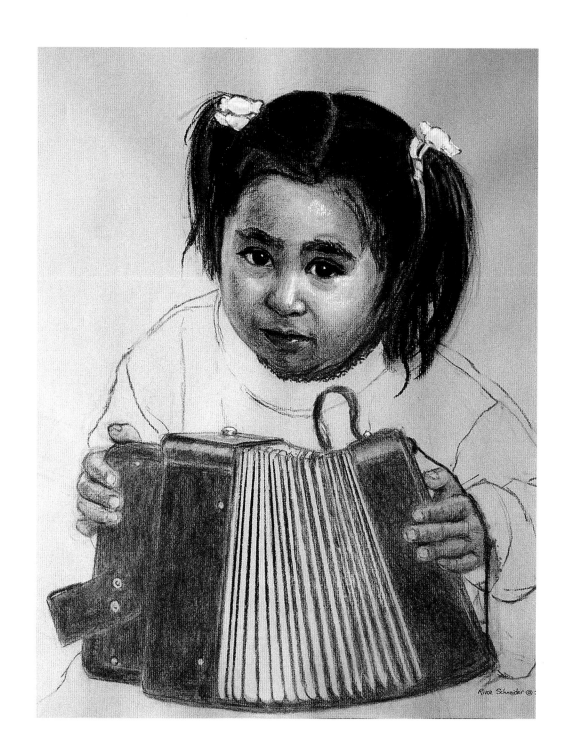

"Two-Year-Old Street
Musician"
Charcoal and conte
22 x 28 inches
(2005)

A Heavy Burden

What is it you carry
Inside that clay pot on your shoulder?
Is it filled with water
For your wife and children to drink?

Or do you carry the heavy burden
Of the displaced,
The weight of memories
From a flooded village
You left behind?

You walk and you walk and you walk
With that weight on your shoulder
As if you were Atlas
Carrying the earth on your back up a hill.

Peso

¿Qué es lo que cargas
En esa cazuela de barro sobre tus hombros?
¿Está llena de agua
Para que beban tu esposa e hijos?

¿O acaso cargas el peso
De los desplazados,
El peso de los recuerdos
De un pueblo inundado
Que dejaste atrás?

Caminas y caminas y caminas
Con ese peso sobre tus hombros
Como si fueras Atlas
Cargando al mundo sobre tu espalda subiendo el cerro.

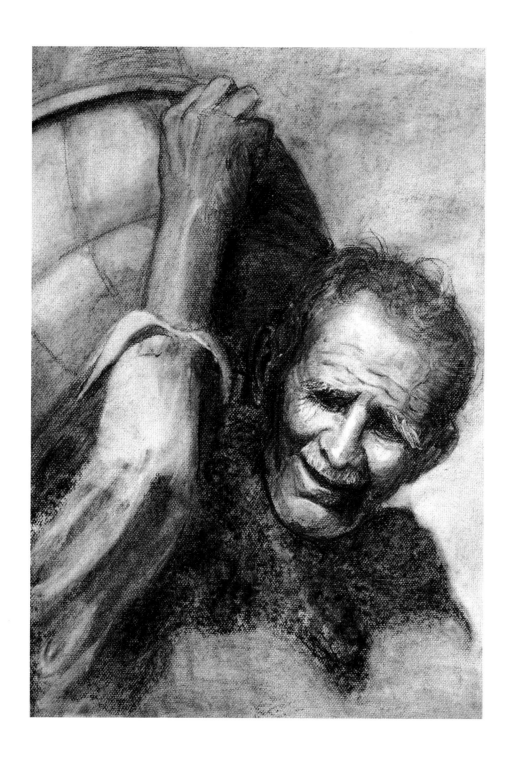

"A Heavy Burden"
Charcoal
24 x 30 inches
(2004)

35

Happy Bead Seller

I stand with these beaded necklaces
Outside La Fogata
Each Saturday afternoon,
Laughing.

I like to listen
To the young children sitting on the curb
With their accordions,
Playing in the sunlight
For shiny dimes
The tourists from "el otro lado"
Toss into paper cups.

I am happy for no reason
Except that I am young
And I am here outside La Fogata
On a busy street
Where my uncles cut hair
In the peluquería
Across from Noe's café
And other kids
Sell silver bracelets
And dive after empty coke bottles.

I hold these brown and white beaded necklaces
In my hand and draped around my arm
Like priceless jewels
Discovered in the white sands of my dreams.

I am only ten years old
And I know that ten is a lucky number
Because I plan to have ten dollars
By the end of the afternoon
One dollar for each necklace I will sell
And one of those dollars
For a raspberry raspa I will buy
At Alyssa's
Where my friends and I will meet
When the sun sinks into the Rio Grande
Like an orange balloon falling from the sky.

El feliz vendedor de abalorios

Me paro con estos collares de abalorios
Fuera de La Fogata
Cada sábado por la tarde,
Riéndome.

Me gusta escuchar
A los niños sentados en la orilla
Con sus acordeones
Tocando bajo el sol
Por brillantes monedas de diez centavos
Que los turistas de "el otro lado"
Arrojan a cucuruchos de papel.

Mi felicidad no tiene motivo
Salvo que soy joven
Y estoy aquí fuera de La Fogata

En una calle transitada
Donde mis tíos cortan cabello
En la peluquería
Frente al café Noe's
Y otros chiquillos
Venden pulseras de plata
Y se lanzan sobre botellas vacías de coca cola.

Sostengo estos collares de abalorios marrones y blancos
En mi mano y colgados sobre mi brazo
Como joyas que no tienen precio
Descubiertas en las blancas arenas de mis sueños.

Sólo tengo diez años
Y sé que el número diez es el de la suerte
Pues pienso juntar diez dólares
Antes que anochezca
Un dolar por cada collar que venda
Y uno de esos dólares
Para una raspa sabor frambuesa que compraré
En Alyssa's
Donde me veré con mis amigos
Cuando se hunda el sol en el Río Bravo
Como un globo anaranjado que cae del cielo.

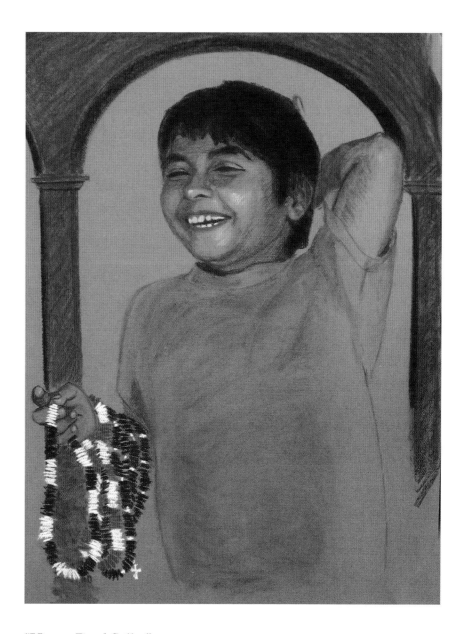

"Happy Bead Seller"
Charcoal and pastel
24 x 30 inches
(2006)

Anciana

En boca cerrada no entran moscas.

Old beggar woman
With white hair of many years:
Snowy egret plumes.

No flies can enter
Her mouth sealed tight with wisdom:
Nobody's old fool!

Anciana

En boca cerrada no entran moscas.

Pordiosera anciana
Con canas de tantos años:
Plumas de garceta blancas como la nieve.

Las moscas no pueden entrar
En su boca bien cerrada de sabiduría:
¡Ninguna vieja tonta!

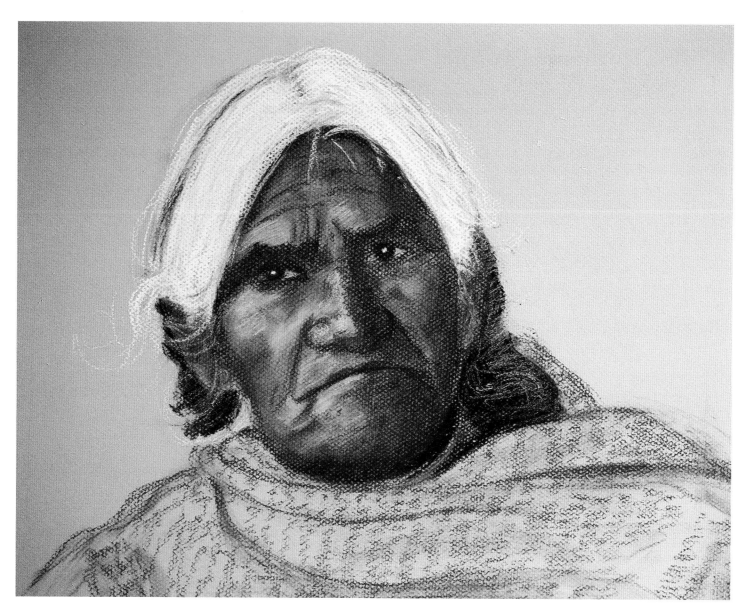

"Anciana"
Conte, 24 x 18 inches (2004)

39

Young Street Musician

She plays the accordion for spare change
In the streets of this bustling border town.
The life she lives is sad, lonely and strange.

She sings ballads with love as their refrain.
The wells of her eyes run deep, dark and brown.
She plays the accordion for spare change.

The sphere of her life has limited range
Though she would like to smile and dance around.
The life she lives is sad, lonely and strange.

Each morning she returns to the same lane
Playing for her food—working hard not to frown.
She plays the accordion for spare change.

She used to sell handbags and golden chains.
Now she plays these songs with their bittersweet sound.
The life she lives is sad, lonely and strange.

On Thursdays she sings in the rain.
Yellow petals fall softly on the ground.
She plays the accordion for spare change.
The life she lives is sad, lonely and strange.

La joven músico ambulante

Toca el acordeón por cambio
En las calles de este pueblo bullicioso en la frontera.
El camino de su vida es triste, solo y extraño.

Canta baladas con el amor como estribillo.
La noria de sus ojos corre profunda, café y obscura.
Toca el acordeón por cambio.

El campo de su vida es limitado
Aunque quisiera sonreír y bailar a la redonda.
El camino de su vida es triste, solo y extraño.

Cada mañana regresa a el mismo paso
Tocando para comer–con una mueca por su cara.
Toca el acordeón por cambio.

Vendía bolsos y cadenas de color dorado.
Ahora toca estas canciones, su música dulce y amarga.
El camino de su vida es triste, solo y extraño.

Los jueves bajo la lluvia se escucha su canto.
Pétalos amarillos caen suavemente sobre la tierra.
Toca el acordeón por cambio.
El camino de su vida es triste, solo y extraño.

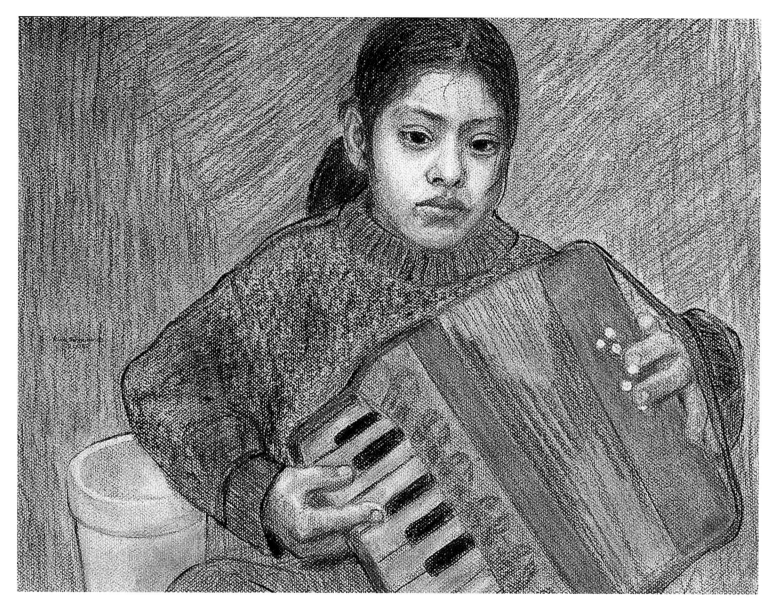

"Young Street Musician"
Charcoal, 30 x 24 inches (2005)

La Bachata

A ring of smoke!
Smoking up the dance floor!
Holy smoke!
Smoky night of palms!
Stoking the smoky charcoal embers!
Smoking guns!
The fires of love smoking!
Music of smoke!
Rhythm of smoke!
Hot sizzling smoking lovers!
Latin smoke!
Border smoke!
Body smoke!
Smoke!

La bachata

¡Un anillo de humo!
¡Quemando la pista de baile!
¡Cielos!
¡Humosa noche entre palmeras!
¡Atizando las brasas humeantes!
¡Armas echando humo!
¡El fuego del amor humeante!
¡La música de humo!
¡El ritmo de humo!
¡Amantes ardiendo entre humos!
¡Humo latino!
¡Humo fronterizo!
¡Humo entre cuerpos!
¡Humo!

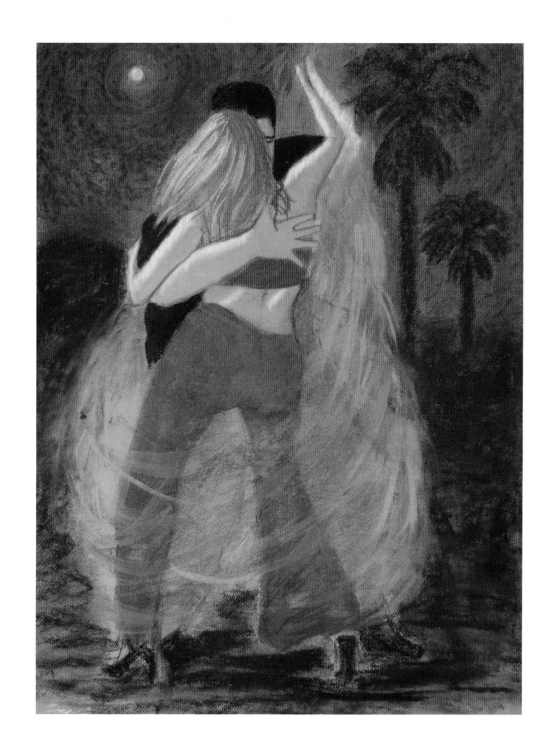

"La Bachata"
Charcoal and pastel
24 x 30 inches
(2006)

43

Rolando

Más vale tarde que nunca

When I first saw her I did not ask for
Her name. In her presence I felt great shame.
From a woman, I could not ask for more.
Before her figure I felt such sharp pain
Running right from my heart down through my knees.
I wanted then to take her in my arms
And kiss the nape of her brown neck, and please
Her with pink roses and magical charms,
Stealing from her a kiss and soft caress.
But I stood frozen before her dark eyes
And wondered if my breathing could persist
Once I became so fully mesmerized.
Years later, she gave me this ring I wear
Around my neck. To her my life I swear.

Rolando

Más vale tarde que nunca

Cuando primero la vi, no le pregunté
Su nombre. Sentí una gran pena ante su presencia.
No podía pedir más de una mujer.
Sentí un dolor punzante ante su figura
Que corría desde mi corazón hasta mis rodillas.
Quise entonces tomarla en mis brazos
Y besar la nuca de su cuello moreno y complacerla
Con rosas color de rosa y amuletos mágicos,
Robándole un beso y una suave caricia.
Pero quedé paralizado ante sus ojos negros
Y me pregunté si mi aliento perduraría
Una vez que me volví enteramente hipnotizado.
Años después me dio ella este anillo que
Cuelga de mi cuello. Mi vida a ella le entrego.

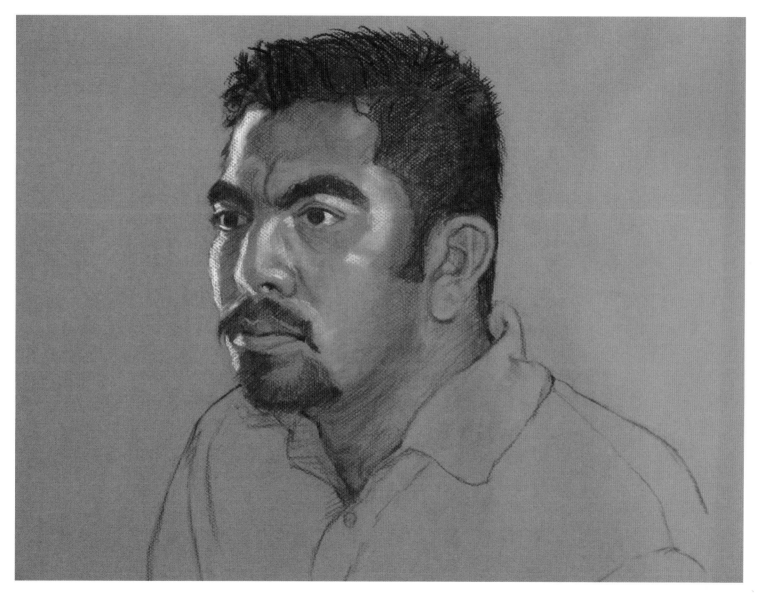

"Rolando"
Charcoal and conte
30 x 24 inches (2002)

Décima: Unfulfilled Dreams

She carries bags on her shoulders
Her dreams for this life unfulfilled
On streets where she walks without will.
The hope for her future smoulders—
In her eyes she looks much older.

Now she longs for another world—
A place where happiness unfurls,
Where her spirit is far lighter,
And in her heart she's a fighter
For a future bright like a pearl.

Décima: Sueños fustrados

Carga bolsas sobre sus hombros
Sus sueños frustrados están
Sobre calles donde vaga sin voluntad
Arden sin llamas sus anhelos
Su mirada muestra los años.

Hoy otro mundo es lo que quiere
Donde la alegría florece
Donde su alma flota ligera
Y en su pecho vive una guerrera
Por un mañana brillante.

46

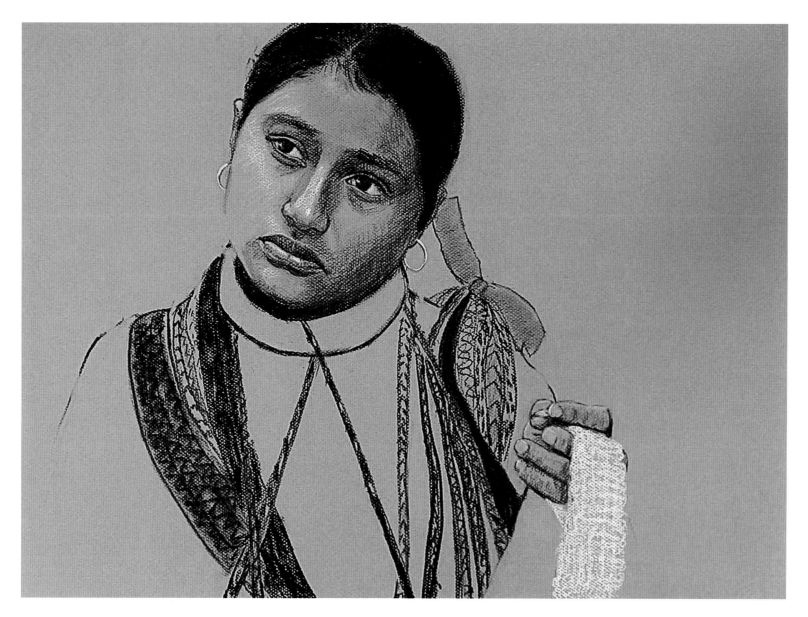

"Unfulfilled Dreams"
Charcoal and conte, 30 x 24 inches (2006)

It's a Lie

The shopkeeper's sign says "don't give money to the children."
Es una mentira.
Our schools have enough teachers.
Es una mentira.
Our teachers have enough classrooms.
Es una mentira.
Our classrooms have enough desks.
Es una mentira.
Our desks have enough chairs.
Es una mentira.
The chairs are waiting for the children.
Es una mentira.
The children should not be begging in the streets.
Es una mentira.
The streets are full of whores.
Es una mentira.
The whores wear dresses with pink flowers.
Es una mentira.
The flowers that I sell feed my family.
Es una mentira.
My family is not proud.
Es una mentira.
The proud river separates our two people.
Es una mentira.
The people would like a fence.
Es una mentira.
The fence will keep us out.
Es una mentira.
Outside, the sky is always blue.
Es una mentira.

Inside, the bluebooks are full of writing.
Es una mentira.
The writing is on the wall.
Es una mentira.
The wall is for all the children.
Es una mentira.
The children can afford to go to school.
Es una mentira.
The school is always open.
Es una mentira.
The open book is always closed.
Es una mentira.
The closed book is always open.
Es una mentira.

Es una mentira

El letrero en la tienda dice--"no les des dinero a los niños."
Es una mentira.
Nuestras escuelas cuentan con suficientes maestros.
Es una mentira.
Nuestros maestros cuentan con suficientes aulas.
Es una mentira.
Nuestros aulas cuentan con suficientes pupitres.
Es una mentira.
Nuestros pupitres cuentan con suficientes sillas.
Es una mentira.
Las sillas esperan a los niños.
Es una mentira.
Los niños no deberían pordiosear por las calles.
Es una mentira.

Las calles están repletas de rameras.
Es una mentira.
Las rameras traen puestos vestidos con flores color de rosa.
Es una mentira.
Las flores que vendo alimentan a mi familia.
Es una mentira.
Mi familia no siente orgullo.
Es una mentira.
El río orgulloso separa nuestras dos gentes.
Es una mentira.
A la gente le agradaría una cerca.
Es una mentira.
La cerca nos mantendrá afuera.
Es una mentira.
Afuera el cielo es siempre azul.
Es una mentira.
Adentro las libretas están llenas de escrituras.
Es una mentira.
Está escrito en la pared.
Es una mentira.
La pared es para todos los niños.
Es una mentira.
Los niños tienen los medios para asistir a la escuela.
Es una mentira.
La escuela siempre está abierta.
Es una mentira.
El libro abierto siempre está cerrado.
Es una mentira.
El libro cerrado siempre está abierto.
Es una mentira.

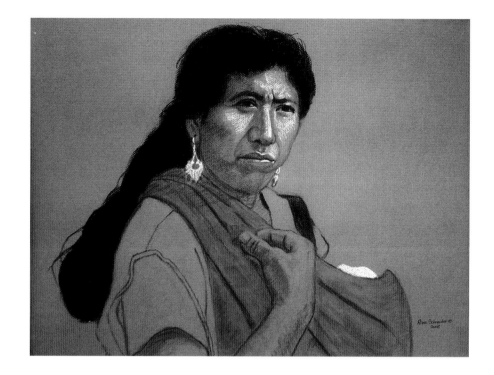

"Es Una Mentira"
Charcoal and conte
30 x 24 inches
(2005)

49

Disappeared

Disappeared into thin air.
Disappeared into black night.
Disappeared in broad daylight.
Disappeared.
Disappeared for speaking out.
Disappeared for remaining silent.
Disappeared for asking questions.
Disappeared.
Disappeared for wearing a Star of David.
Disappeared for wearing a Cross.
Disappeared for belonging to a union.
Disappeared.
Disappeared in Chile.
Disappeared in Guatemala.
Disappeared in El Salvador.
Disappeared.
Disappeared from family picnics.
Disappeared from wives wrapped in shawls.
Disappeared from mothers and grandmothers.
Disappeared.
Disappeared from market places.
Disappeared from cafés.
Disappeared from nightclubs.
Disappeared.
Disappeared from the avenues of palm trees.
Disappeared from the fields of sugar cane.
Disappeared from the rooms of the living.
Disappeared.

Disappeared from the town square with its fountains.
Disappeared from vigils.
Disappeared from the candlelit night.
Disappeared.
Disappeared from Ciudad Juárez.
Disappeared from maquiladores.
Disappeared from the face of the earth.
Disappeared.

Desapareció

Desapareció en la nada.
Desapareció en la noche negra.
Desapareció en plena luz del día.
Desapareció.
Desapareció por levantar su voz.
Desapareció por permanecer callado.
Desapareció por hacer preguntas.
Desapareció.
Desapareció por llevar la estrella de David.
Desapareció por usar una Cruz.
Desapareció por pertenecer al sindicato.
Desapareció.
Desapareció en Chile.
Desapareció en Guatemala.
Desapareció en El Salvador.
Desapareció.
Desapareció de comidas campestres con la familia.
Desapareció de esposas envueltas en mantas.
Desapareció de madres y abuelas.

Desapareció.
Desapareció de mercados.
Desapareció de cafés.
Desapareció de centros nocturnos.
Desapareció.
Desapareció de las avenidas con palmeras.
Desapareció de los campos de caña dulce.
Desapareció de los cuartos do los vivientes.
Desapareció.
Desapareció de la plaza del pueblo con sus fuentes.
Desapareció de la vigilia.
Desapareció de la noche en luz de vela.
Desapareció.
Desapareció de Ciudad Juárez.
Desapareció de las maquiladoras.
Desapareció de la faz de la tierra.
Desapareció.

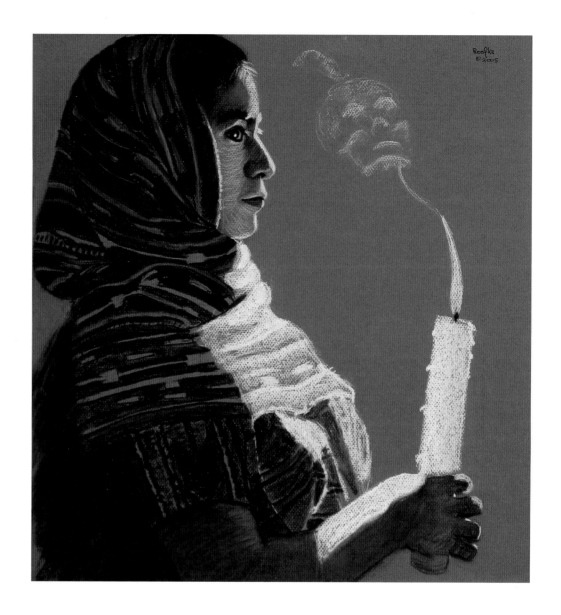

"Mass for the Disappeared"
Charcoal and conte
22 x 28 inches
(2005)

Acknowledgments

Many thanks to José Antonio Rodríguez for his wonderful translations of these poems and to José Skinner for taking the time to look them over. Thanks also to Professor Norma E. Cantú for her passionate and cogent Introduction to this book.

We would also like to thank the editors of *Afro-Hispanic Review* and *Writing Toward Hope,* William Luis and Marjorie Agosín, for publishing several of these drawings in their publications.

Heartfelt gratitude to Marjorie Agosín and Lawrence Caylor for believing in us from the beginning; to Patrick Hamilton for sharing his photographs with Reefka; and to Roland Ariola, Dahlia Guerra, and Anthony Crisafulli for their generous support during the development of our poetry-art traveling exhibit *Borderlines: Drawing Border Lives.*

We are deeply grateful to Bryce Milligan of Wings Press for making this book happen. And most of all we want to thank all of the gente de la frontera that Reefka drew, who posed for her and shared their stories with words and with their eyes.

Artists' Statement

Reefka Schneider and Steven P. Schneider

By placing poetry and art side by side we invite you into a world of image and word, figure and figure of speech, a world in which the borders of one medium touch another. In this way our "marriage" of art and poetry reflects the creative synergy of the people who live on both sides of the River—what one side calls Rio Grande and the other side calls Río Bravo.

In a world in which borders continue to be sites of conflict and mistrust, we offer this book as a testimony to the people who live and work along the U.S.–Mexico border in the Rio Grande Valley. You will see in these drawings and poems a reflection of life along the border. It is a story of the human spirit and its quest for happiness and fulfillment, its struggles to survive and overcome economic hardship.

We hope this collection will improve cross-cultural understanding and deepen awareness of the human ties that bind all of us together.

Declaración de los artistas

Al colocar la poesía y el arte lado a lado los invitamos a ustedes a un mundo de imagen y palabra, de forma y foma de expresión, a un mundo en donde los limites de un medio alcanzan otro. De esta manera nuestro "matrimonio" entre el arte y la poesía refleja la sinergia creativa de la gente que vive en ambos lados del río, el que un lado llama el Rio Grande y el otro lado llama el Río Bravo.

En un mundo donde las fronteras siguen siendo lugares de conflicto y desconfianza, ofrecemos este libro como testimonio a la gente que vive y trabaja a lo largo de la frontera México–Estados Unidos en el Valle del Río Grande. Verán en estos dibujos y poemas el reflejo de la vida a lo largo de la frontera. Es una historia de la voluntad del ser humano y de su busqueda por la felicidad y la autorealización, su lucha por sobrevivir y por superar las dificultades económicas.

Esperamos que esta colección mejore el entendimiento entre las dos culturas y profundice el conocimiento de los lazos humanos que nos unen a todos.

Steven P. Schneider, Poet

Steven P. Schneider is Professor in the Department of English at the University of Texas-Pan American, where he also serves as Director of New Programs and Special Projects for the College of Arts and Humanities. Steven is a founding member of the South Texas Literacy Coalition in the Rio Grande Valley and is the recipient of two Big Read grants from the National Endowment for the Arts. He has used the *Borderlines: Drawing Border Lives* traveling exhibit to promote the teaching of culturally relevant literature and creativity. Steven offers a variety of workshops on these topics to both high school and college students and teachers.

Steven Schneider has published his poetry widely and given readings throughout the United States, including public performances at the Iowa Summer Writing Festival, the Fort Kearny Writers' Conference, the UTPA Summer Creative Writing Institute, and the South Texas Literary Festival. He has also been interviewed and read his work on NETV. Steven Schneider's poems and essays have been published in national and international journals, including *Critical Quarterly, Prairie Schooner, Tikkun, The Literary Review,* and featured in *American Life in Poetry.*

He is the author of several books, including two collections of poetry, *Prairie Air Show* and *Unexpected Guests,* and a scholarly book entitled *A.R. Ammons and the Poetics of Widening Scope* and the editor of *Complexities of Motion: New Essays on A.R. Ammons's Long Poems.* He is a winner of an Anna Davidson Rosenberg Award for Poetry and a Nebraska Arts Council Fellowship.

José Antonio Rodríguez, Translator

José Antonio Rodríguez, born in México and raised in South Texas, is a bilingual poet and translator. He is currently a graduate student in the English and Creative Writing program at the State University of New York at Binghamton. His poems have appeared in various journals, including the *Paterson Literary Review, Spoon River Poetry Review, BorderSenses, Borderlands: Texas Poetry Review,* and *Cream City Review.*

Reefka Schneider, Artist

Reefka Schneider is one of the foremost artists of "la frontera," the binational region of the Rio Grande Valley in South Texas. Her artwork reflects the social and economic realities of the border while celebrating the local culture, people, and music. Reefka lives in McAllen, Texas with her poet husband Steven.

Yvonamor Palix, international art curator, likens Reefka's drawings to the work of Francisco Zuniga, noting "Although similar in subject matter, his works do not portray these characters in such a human and real manner." Ricardo Contreras Soto, anthropologist and co-editor of *Paz y conflicto religioso: Los indígenes de México,* describes Reefka's work as an "estético peligroso" – a dangerous aesthetic. Drawings from *Borderlines: Drawing Border Lives* were featured in the book *Writing Toward Hope: The Literature of Human Rights in Latin America* (Yale University Press, 2006) and in the *Afro-Hispanic Review* (Vanderbilt University Press, 2008).

Two Afro-American artists of past and present, Charles White and Dean Mitchell, have influenced Reefka greatly. Dean Mitchell has said, "I would hope that my work can bring people together. Art has a way to bridge and heal wounds." Reefka also strives to give a voice and a face to those who have none.

Reefka has had exhibitions at The University of Texas-Pan American, Edinburg, Texas, the Rockport Center for the Arts, Rockport, Texas, The International Museum of Art and Science, McAllen, Texas, Northwest Vista College, San Antonio, Texas, and the Art Center for the Islands, Port Aransas, Texas. She is represented by Nuevo Santander Gallery in McAllen, Texas.

For more information about the artists, their traveling exhibits
and educational workshops, please visit their website at www.poetry-art.com

Colophon

This first edition of *Borderlines: Drawing Border Lives / Fronteras: Dibujando las vidas fronterizas,* with poems by Steven P. Schneider and drawings by Reefka Schneider, has been printed on 70 pound paper containing fifty percent recycled fiber. Titles have been set in Papyrus type, the text is in Adobe Caslon type. All Wings Press books are designed and produced by Bryce Milligan (con gracias to Reefka Schneider for her insights).

Wings Press was founded in 1975 by Joanie Whitebird and Joseph F. Lomax, both deceased, as "an informal association of artists and cultural mythologists dedicated to the preservation of the literature of the nation of Texas." Publisher, editor and designer since 1995, Bryce Milligan is honored to carry on and expand that mission to include the finest in American writing—meaning all of the Americas, without commercial considerations clouding the choice to publish or not to publish.

Wings Press attempts to produce multicultural books, chapbooks, ebooks, CDs, DVDs and broadsides that, we hope, enlighten the human spirit and enliven the mind. Everyone ever associated with Wings has been or is a writer, and we know well that writing is a transformational art form capable of changing the world, primarily by allowing us to glimpse something of each other's souls. Good writing is innovative, insightful, and interesting. But most of all it is honest.

Likewise, Wings Press is committed to treating the planet itself as a partner. Thus the press uses as much recycled material as possible, from the paper on which the books are printed to the boxes in which they are shipped.

As Robert Dana wrote in *Against the Grain,* "Small press publishing is personal publishing. In essence, it's a matter of personal vision, personal taste and courage, and personal friendships." Welcome to our world.

On-line catalogue and ordering: www.wingspress.com • Wings Press titles are distributed to the trade by the Independent Publishers Group: www.ipgbook.com • European distribution by Gazelle Book Services: www.gazellebookservices.co.uk